CONTENTS

Note: The dates above indicate the years when the particular movement was at its height. As you will see, the ideas overlap and crop up from time to time in paintings from the mid-1800s to the present time.

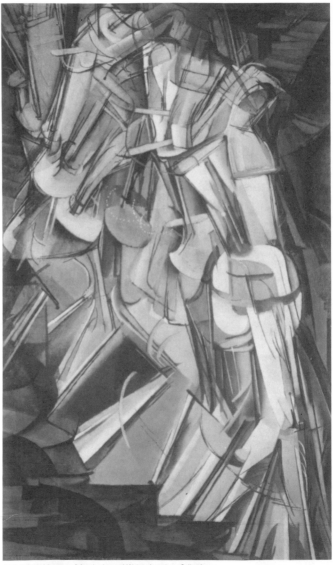

Marcel Duchamp
American, 1887–1968
Nude Descending a Stair-case, No.2. 1912
Oil on canvas, 58 x 35"

Philadelphia Museum of Art. Louise and Walter Arensberg Collection

INTRODUCTION

Why is some art disturbing and shocking? In some paintings, many viewers see nothing familiar, nothing they can relate to the visible world around them; other pictures may include figures or objects, but they are distorted, dismembered or fractured beyond recognition. Some people are scornful; "My five-year-old could do better than that!" Others would like to understand but are confused. What is going on in the art world today? This book invites you to look again and offers clues to understanding modern paintings.

Art that shocks is not a recent development. The modern art movement began in France in the 1860s as a protest against traditional art. In the previous five hundred years, beginning with the Renaissance, artists in the Western world served a very specific purpose. Most people were illiterate and there were no books for the masses anyway; artists had to be historians and storytellers. Their paintings recorded contemporary events and leaders, depicted Bible stories, illustrated myths and folktales. The picture frame was like a proscenium arch within which viewers saw pictorial representations of events and stories thought important. They read the content of paintings as we read books and magazines.

During those five hundred years, artists with few exceptions followed traditional rules taught by master artists or art academies. Whatever the subject matter, the artists imitated life—the visible world around them—and the viewer recognized and related to the subject matter. The laws of perspective were formulated so that the illusion of three-dimensional space could be conveyed on a two-dimensional canvas. Composition—the use of space within the frame—

was carefully regulated to draw the eye to the central theme. Colors were harmonious, and the texture was smooth, without obvious brushstrokes to break the illusion. Altogether, there was nothing shocking to the sensibilities of the viewers. Artists might have continued to be historians and storytellers in the twentieth century, except for a dramatic shift in nineteenth-century life in the Western world. Tremendous political, social and technological changes brought trains, steamboats, electricity, telephones into daily life. Free education was offered. Improved presses produced low-cost books; newspapers recorded daily events.

For painting, the greatest change of all came with the invention of the camera. Historic events could be recorded on the spot. Portraits could be commissioned at modest cost and at great savings in time. Some artists feared that the camera would do away with the need for paintings; others borrowed certain photographic effects to create a new kind of composition on canvas. A few painters made of the invention of the camera an opportunity to break with traditionalism and do something new. Freed from the role of historian/storyteller, they could paint what and how they wanted. And they did. The early results, called Impressionism, were shocking to the public. The paintings seemed blurry, as though the artists needed eyeglasses, and totally lacking in straight lines. One critic commented that children could do better; a cartoonist warned pregnant women that looking at the paintings might cause miscarriage.

Although breaks with traditional painting had been made earlier in the Romantic and Realist movements, Impressionism is generally considered the first major step into modern art.

IMPRESSIONISM: 1863-1886
The Discovery of Sunlight
Manet, Morisot, Monet, Renoir

Oscar Claude Monet
French, 1840–1926
Water Lilies (1). 1905
Oil on canvas, 35¼ x 39½"

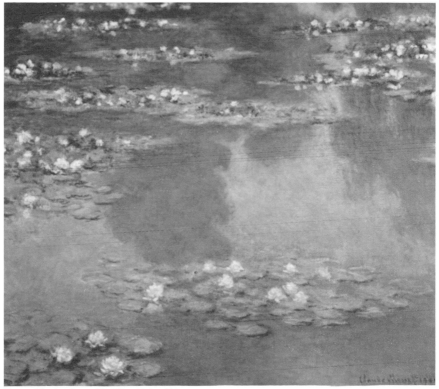

Museum of Fine Arts, Boston. Gift of Edward Jackson Holmes

It was Gustav Courbet who, in the mid-nineteenth century, made one of the first schisms with traditional painting by questioning its subject matter. He stated that artists should paint only what they could see, and who had ever seen angels or a Greek god? To the outrage of the traditionalists, he began painting ordinary people in down-to-earth situations and thereby became the founder of Realism.

The Impressionists—Manet, Morisot, Monet, Renoir and others—emerged from the Realism movement to question what an artist really did see. Although the Realists had made a breakthrough with a drastic change in subject matter, artists were still painting by the same five-hundred-year-old rules. Figures and objects were frozen inside a frame in carefully planned composition painted in a studio. Was this what the Realists really saw?

Then the questioners "discovered" sunlight. Optics, the science of light, discovered that the sun, in addition to being nature's source of energy, was also the source of color. The light of the sun, when passed through a prism, splits into the primary colors—red, yellow, blue. When these overlap, the secondary colors—orange, green, violet—appear. At about the same time, new paints made from chemicals added brilliant, intense colors to the artist's palette.

Artists absorbed the current ideas from optical laboratories, looked outside, saw the world in a different light and became obsessed with sunlight. They moved out of their studios to paint outdoors. This was unheard of; traditionally, the artist made sketches outside but finished the painting in a studio.

With sunlight the main subject, landscapes, people, city scenes were only objects to be bathed in it. Artists found that colors changed constantly as one looked at them. To catch the effect of movement and change, they made hundreds of small dabs, ovals and short brushstrokes instead of filling the canvas with solid colors. Furthermore, they did not mix

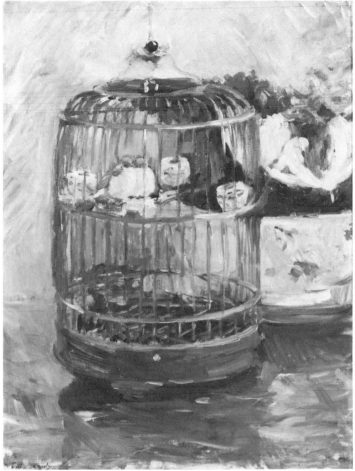

Berthe Morisot
French, 1841–1895
The Cage. 1885
Oil on canvas, 19⅞ x 15″

The National Museum of Women in the Arts, Washington, D.C. Gift of Wallace and Wilhelmina Holladay

Pierre-Auguste Renoir
French, 1841–1919
*The Luncheon of the Boating
Party.* 1881
Oil on canvas, 51 x 68"

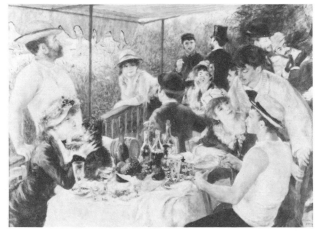

The Phillips Collection, Washington, D.C.

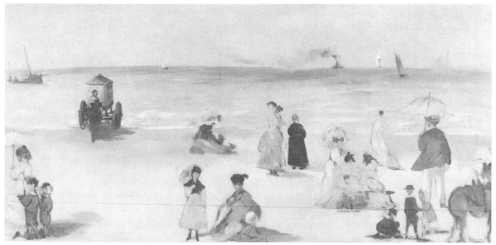

Virginia Museum of Fine Arts, Richmond. Gift of Mr. and Mrs. Paul Mellon

Edouard Manet
French, 1832–1883
*On the Beach,
 Boulogne-sur-Mer.* 1869
Oil on canvas, 21½ x 34½"

colors on a palette. Instead, they put dabs of pure color—such as blue and yellow—directly on the canvas side by side. and let the viewer's eyes mix them to make green.

Discovering that shadows contain reflections of the colors surrounding them, the Impressionists stopped using black paint to create them. They observed that the fluid light of the sun softens the edges of objects, so they simply dabbed broken lines to suggest trees, people, even buildings. As a result, if the viewer stands very close to an Impressionist painting, he sees only meaningless spots.

The overall effect was that of a fleeting moment in time. Nothing was still. People were caught in the midst of doing something, going somewhere; they never posed.

"Is this art?" the traditionalists asked in ridicule, and the public laughed. One critic wrote that a new painting could have been done by "a monkey who might have got hold of a box of paints."

It wasn't until the twentieth century that Impressionism became widely accepted. Today many popular paintings from the period are reproduced on a large scale. The originals are becoming priceless. In 1988 a painting by Claude Monet sold for $24.3 million, breaking all previous sales records for Impressionist art.

In Edouard Manet's beach scene pictured here, the sunlit sea, sky and water predominate. People and objects are indicated by dabs of paint; yet all are recognizable. As in a candid camera shot, there is no central focus, people are looking in different directions, and the mule on the right is half out of the picture. Berthe Morisot's bird cage has no solid lines, only short brushstrokes of paint. Monet's water lilies are done in a similar way. In Pierre-August Renoir's scene the people are unposed, again as in a candid camera shot. In a larger reproduction, it would be apparent that the faces and clothes, the fruit, wine bottles and glasses are composed of short strokes and dabs of the brush.

POSTIMPRESSIONISM: 1886-1905
Beyond Sunlight
Cézanne, Seurat, Gauguin, Van Gogh

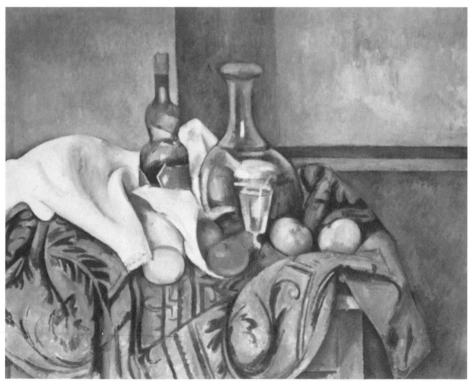

National Gallery of Art, Washington. Chester Dale Collection

Paul Cézanne
French, 1839–1906
*Still Life with Peppermint
 Bottle.* c. 1894
Oil on canvas, 26 x 32⅜"

The next time you pick up an apple, think of Paul Cézanne before you bite into it. Cézanne thought that, in all of nature, fruits had the purest color; that is, light falling on them produced the richest tones.

Although one of the original Impressionists, Cézanne became dissatisfied with the movement's exclusive interest in sunlight. After all, nature's objects are not just casual dabs of color; light falling on them proves that they are actually solid. Famous for his still-life paintings, he carefully structured the shapes of fruits with broad brushstrokes and color contrasts to create planes and give the effect of great solidity. Sometimes the process took so long that the fruits he painted from shriveled up. He saw all shapes in nature as based on "the cone, the cylinder and the sphere." Some of these geometric shapes can be seen unobtrusively in his still-lifes and his mountain landscapes and figure paintings. He would "build" a mountain on canvas by making blocks and angular shapes with brush and color. Cézanne often distorted the traditional imitative perspective (more on this later) to improve his compositions. To him, because the camera could record everything exactly, the artist was free to change reality or even abandon it altogether.

With Cézanne a new movement called Postimpressionism was born. Seurat, Gauguin and Van Gogh, fellow former Impressionists, also began putting solids back into their paintings, but in entirely different ways. Georges Seurat researched the science of light and color in far greater depth than had the Impressionists and reduced the dabs of paint to small dots or points. Looking at a scene, he visually broke it down into millions of dots of innumerable colors, then transferred them with a pointed brush on to a canvas. Placed very close together, the myriad points created an illusion of solidity. His technique can be compared to the way color television works. The video camera focuses on a scene and breaks it into millions of electronic impulses

comparable to Seurat's dots, which are transmitted by radio and reassembled almost simultaneously onto your TV screen. You can see the dotlike assemblage if your TV picture is grainy. But Seurat, living decades before the invention of television, did the process by hand, painstakingly, dot by dot, and on a much bigger scale. The actual size of the reproduction here is 7 x 10 feet! He took up to two years to complete one painting. Others used this "Pointillism" or "divisional" technique, but none were as precise as Seurat. Seurat left few paintings compared to the other Impressionists; he died of pneumonia at age thirty-one.

Gauguin had different ideas about color. If a tree looks green to you, he told young artists, then paint it a brilliant green. Why mix and muddy up colors trying to imitate nature? Gauguin, living in Paris, was disgusted with what

Georges Seurat
French, 1859–1891
Sunday Afternoon on the Island of La Grande Jatte. 1884–86
Oil on canvas, 6'9" x 10'

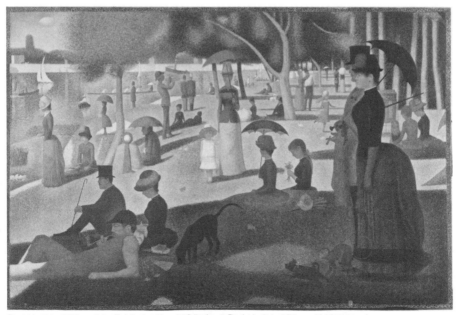

was happening. The Industrial Revolution made men greedy for materialistic comforts and the arts and humanities were ignored. Looking for a simpler life, one where people were uncorrupted by the modern world, he moved to the country and finally to Tahiti.

Best known for his Tahitian paintings, he drew simple figures, outlined them heavily and painted them with exaggerated and often clashing colors. The result often has a flat, decorative quality like a tapestry or a stained glass window. The overall effect is of serenity.

Vincent van Gogh was an admirer of Cézanne who looked at nature in a different way. Cézanne strove to build nature's objects solidly on canvas; Van Gogh saw all nature as alive and constantly moving. In his landscapes he seems to peer into the very core of nature—trees, flowers, fields, hills—to discover the hidden vital energy that makes it perpetually alive. "Real artists paint things not as they are, in a dry analytical way, but as they feel them," he wrote. Like Gauguin, Van Gogh used pure, brilliant colors and thought that "color expresses something by itself," but Van Gogh's paintings are far from serene. Squeezing ribbons of paint directly from the tubes on to the canvas and applying long

Paul Gauguin
French, 1848–1903
D'ou Venons-Nous? Que Sommes-Nous? Ou Allons-Nous? 1897
Oil on canvas, 54¾ x 147½"

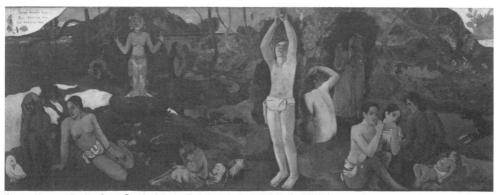

Courtesy, Museum of Fine Arts, Boston. Tompkins Collection. Purchase, Arthur Gordon Tompkins Fund, 1936

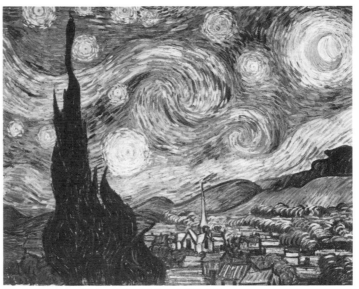

Vincent van Gogh
Dutch, 1853–1890
The Starry Night. 1889
Oil on canvas, 29 x 36¼"

Collection, The Museum of Modern Art, New York. Bequest of Lillie P. Bliss

and short brushstrokes of thick paint, he covered the canvas with passionate, vibrant movement.

He also was deeply concerned about the modern world and foresaw inevitable disaster. But, instead of trying, like Gauguin, to return to an innocent past, he wrote that in spite of catastrophes he hoped through painting to touch people's hearts. A few of his paintings were sold, for a total of one hundred dollars, before he committed suicide in 1890. In 1987, however, one of his iris paintings broke all art sale records when it was sold for $53.9 million. Earlier the same year, a sunflower painting brought $39.9 million.

Van Gogh became known as one of the first Expressionists. While the Impressionist paints fleeting surface impressions of what he sees, the Expressionist wants to express his personal feelings, to transmit his innermost emotions about what he sees to the viewer.

FAUVISM: 1905–1907
Wild Beasts, Wild Colors

Matisse, Vlaminck

Henri Matisse
French, 1869–1954
Dance (first version). 1909
Oil on canvas, 8'6½" x 12'9½"

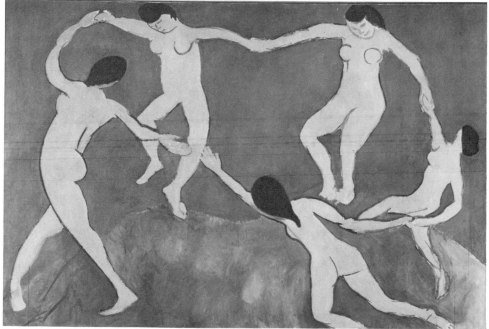

Collection, The Museum of Modern Art, New York. Gift of Nelson A. Rockefeller, in honor of Alfred H. Barr, Jr.

At the first public showing of Fauvist artists in 1905, a viewer was shocked at a portrait of a woman with a green-tinted face, red hair beside one ear, black by the other, and a weird splotchy background. He told the artist that it didn't look like a woman. The artist replied, "It is not a woman; it is a painting."

The artist was Henri Matisse, the leader of a group called Les Fauves—"wild beasts" in French. The show caused such violent reactions from the public and critics that Matisse wouldn't allow his wife—the model for the green-faced woman—to attend.

A better name than Wild Beasts might be Wild Colorists: it was the unnatural use of color that infuriated the public. Color is a fundamental ingredient of painting, and throughout five centuries of Western art it had always been used representationally: grass was green, sky blue, skin flesh-colored. Although artists in the nineteenth century, rebelling against academic rules, had made changes that shocked the public, their colors had remained representational. Postimpressionist Van Gogh exaggerated and intensified nature's color, but his foliage was still green, his sunflowers yellow. Gauguin sometimes inserted a completely unrealistic color, such as a red field, in a landscape, but other colors in the picture remained representational.

At the beginning of the twentieth century, the Fauves went further. Leaving details out of their picture, they took color to the extreme of nonrepresentation: purple trees, red people, pink houses, greenish faces. The idea spread like wildfire. Artists all over Europe became Fauvists, reveling in and taking advantage of the liberation of color from the rigid confines of traditional representation.

The Fauvist movement lasted only two years, but it had served its purpose. Artists could now freely use color outside the bounds of traditionalism. The Fauvists went their separate ways, seeking new directions. For some, Maurice de

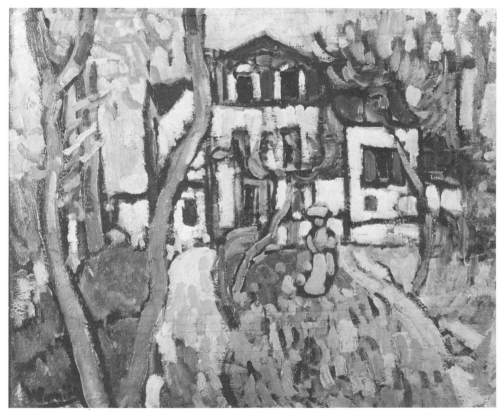

The Minneapolis Institute of Arts. Bequest of Putnam Dana McMillan

Maurice de Vlaminck
French, 1876–1958
The Blue House. c. 1905
Oil on canvas, 21½ x 25½"

Vlaminck among them, Fauvism inspired their best works. For Matisse, it was a stepping stone. He moved on to become the foremost colorist of the twentieth century. In the forty years following his Fauvist period, until his death in 1954, Matisse moved from bold designs on large canvases to small paintings with patterns of color and light. Finally, as an invalid in his seventies, he made extraordinary paper cut-outs, creating large murals with scissors and painted paper.

The shock viewers and critics felt on seeing the Fauvists' unnatural use of color is hard to understand almost a century later. We've seen color go every which way in the ensuing art movements, including those of the present day. You can get some of the initial effect of Fauvism if, during a TV program, the color on your screen suddenly goes berserk. Faces may be orange outlined in purple, the background a vibrating green. The abrupt shift from representational color hurts the eyes and confounds the brain. You can quickly readjust the color on TV, however. In the case of Fauvist art, the public had no such control. Yet eventually many people came to like the wild color explosion of these pictures.

Because it is impossible to reproduce the "Wild Beast" paintings creditably in black and white, only two Fauvists are represented here. Fauvism is too important a movement to leave out, however. You have to imagine the salmon color of the dancing nudes (brilliant red in similar versions by Matisse), the red and pink tree trunks and blue roof in Vlaminck's scene.

CUBISM: 1908–1914
The Demise of Perspective
Picasso, Braque, Gris, Léger

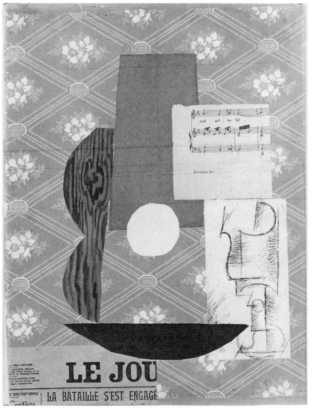

Pablo Picasso
Spanish, 1881–1973
Guitar and Wine Glass. 1912
Collage and charcoal,
18⅞ x 14⅜"

The McNay Art Museum, San Antonio, Texas. Bequest of Marion Koogler McNay

If the colors of the Wild Beasts tortured the viewer's eyes, the movement that followed theirs caused further visual distress. In 1908, as Fauvist artists sought new directions, Braque submitted a painting for an exhibition. Matisse, a fellow Fauve and one of the judges, took a look at Braque's "new style" and in disgust pronounced it nothing but cubes, "always the cubes." The painting was rejected. (Artists are often each other's worst critic.) The new style soon became known as Cubism—somewhat of a misnomer, as you'll see when you look closely. Are there any cubes among the geometric shapes?

Cézanne had laid the foundation of Cubism in the 1890s with the idea that all objects in nature could be reduced to three forms—the cone, the sphere and the cylinder. He had also distorted perspective in his paintings, though his modifications are hardly noticeable to the untrained eye. Braque and Picasso, inventors of Cubism, were great admirers of Cézanne, whose ideas they borrowed and extended. They saw not just three but an infinite variety of geometric shapes. Sharing a studio, they would set up a still-life with familiar objects—wine bottles, glasses, musical instruments—then analyze these objects, breaking them into different geometric planes. In the process of painting the planes on the canvas, they often rearranged them so that, for example, one saw not only the front view of a figure or guitar but also the profile and three-quarter view. (Picasso, who worked in many different styles later, used the multi-view idea in the thirties; his faces with both eyes on one side of the nose are particularly well-known.) In other words, perspective as we know it was discarded.

This idea was so preposterous that the public didn't bother to go to Cubist showings. If previous modern art movements had infuriated people and been accused of causing miscarriages, at least the responsible artists had retained perspective. The use of perspective in pictures began with

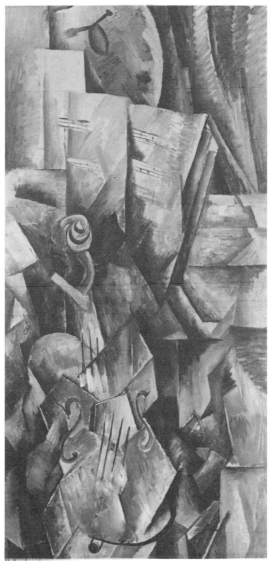

Georges Braque
French, 1882–1963
Violin and Palette. 1910
Oil on canvas, 36⅛ x 16⅞″

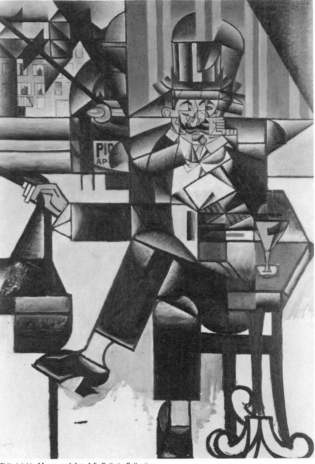

Philadelphia Museum of Art. A.E. Gallatin Collection.

the Greeks and Romans in the Western art world; the
Renaissance artists mathematically perfected the illusion of
three dimensions (height, width and depth) on a flat, two-
dimensional surface. Five centuries ago viewers expected art
to use perspective to mirror their views of reality: what is

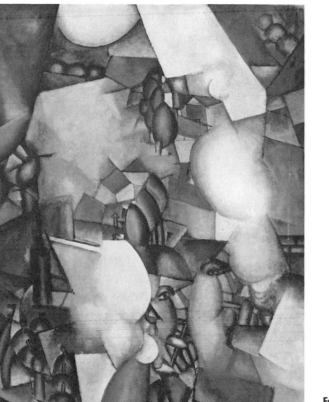

Fernand Léger
French, 1881–1955
The Smokers. 1911–12
Oil on canvas, 51 x 38″

near is large and clearly three-dimensional; farther objects are smaller and less apparently deep (that is, they approach two-dimensionality).

Despite the public reaction, the Cubists were not about to turn back. Whether they were aware of it at the time or

not, they were making the biggest break so far with tradi-
tionalism. They were removing the illusion of depth and
using the canvas for what it is—a flat, two-dimensional sur-
face. To further eliminate perspective, Picasso and Braque
began integrating two-dimensional pieces of paper into
their paintings and soon made entire pictures of scraps of
newsprint, playing cards, wallpaper. This new technique was
called collage, from the French verb, *coller*—to paste. In time
all sorts of materials were used. In future movements, col-
lage became more complicated than the Cubists could have
imagined.

In the picture by Georges Braque shown here, the
realistically painted nail holding the palette in the upper
lefthand corner is an interesting touch. In Pablo Picasso's
collage, the wine glass is a charcoal sketch he drew on a
separate piece of paper. Other important Cubist artists
using variations of the original techniques are Juan Gris and
Fernand Léger. Gris often combined traditional perspective
with flat planes. Note the buildings outside the window in
the lefthand background. Léger combined flat planes with
curved areas.

People still find Cubism hard to understand. It is one of
the most important movements in the twentieth century
because it finally freed art from the tradition of five cen-
turies that required paintings to imitate nature and to incor-
porate linear perspective. Also, by introducing collage,
Cubism showed that other materials could be used in many
combinations with paint.

The Cubists' idea of flattened perspective has seeped
into our daily lives. You see it in printed ads and TV and in
textile designs. The earliest use was in World War I. In 1914,
Picasso saw on a street in Paris a strangely painted French
Army truck followed by similarly camouflaged vehicles. He
said to his companion, "It is we who made it! That is
Cubism!"

ABSTRACTIONISM: 1908–1920s
The Disappearance of Recognizable Objects
Kandinsky, Malevich, Mondrian, O'Keeffe

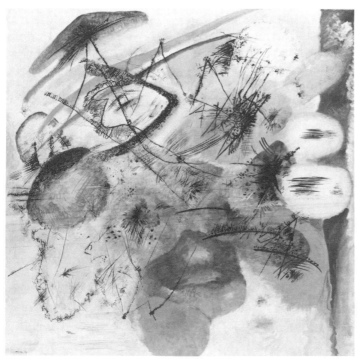

Wassily Kandinsky
Russian, 1866–1944
Black Lines. 1913
Oil on canvas, 51 x 51⅝"

According to his autobiography, the Russian Wassily Kandinsky came into his studio late one afternoon and saw in the dusky light a strange painting. The picture had no subject matter or recognizable content—only varied shapes and brilliant colors. He was emotionally "profoundly affected," then recognized the painting as one of his own mistakenly placed sideways against the wall. Why was he so moved by a picture with no familiar objects in it?

Kandinsky had had traditional art training. Influenced by modern art movements, he experimented with Impressionism and Postimpressionism. At this time he was painting landscapes with the wild colors of Fauvism but searching for something else. As a student of theosophy and a mystic, he believed that materialism was concealing, suppressing, the universal spirit of man.

His rotated painting stirred him emotionally more than the upright work did. Color, line and form, unattached to recognizable objects, appeared to be universal symbols similar to the tones and tempos of music. Certain colors and lines tend to evoke gaiety or sadness, as do certain musical tones and chords. Inspired, he gradually began to eliminate objects from his paintings.

Finally in 1910 Kandinsky painted what many art historians consider the first totally abstract, or nonrepresentational, painting to be exhibited in the Western world—a water color. But pieces of recognizable objects continued to be seen in his work for several years. Later, in the twenties and thirties, he moved into geometrical abstract painting (see the cover of this book).

Kandinsky was by no means the only artist to "discover" abstraction. Simultaneously all over Europe, an interest in occultism, magic and mysticism was pushing artists in Italy, Holland, Russia to search for new meanings in life beyond materialism.

Abstraction was achieved in very different ways. Kasimir

Malevich in Russia had moved from Realism to Cubism, which had a following during these same years. As noted in the previous chapter, Cubism still had subject matter, even though it was splintered, broken up almost beyond recognition. Malevich was a devout Christian mystic who wrote, "The visual phenomena of the objective world are, in themselves, meaningless; the significant thing is feeling, as such, quite apart from the environment in which it is called forth." In trying to find ways to eliminate even the fragments of objects in Cubism, he wrote, "In the year 1913, in my desperate attempts to free art from the burden of the object, I took refuge in the square form and exhibited a picture which consisted of nothing more than a black square on a white

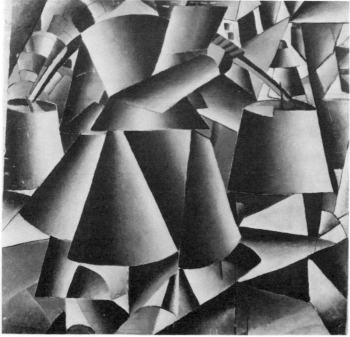

Kasimir Malevich
Russian, 1878–1935
Women with Water Pails:
 Dynamic Arrangement. 1912
Oil on canvas, 31⅝ x 31⅝"

field." This was to him as much a spiritual revelation as the rotated painting had been to Kandinsky. Malevich was the first painter to remove objects from Cubism and to deal with geometric form for its own sake. The picture shown here is a transitional one; the only recognizable subject matter is the arm and hand (holding the crossbar with pails) and the indication of buildings above that. Without a title, what would this painting mean to you?

Within these same years, Piet Mondrian, a Dutchman,

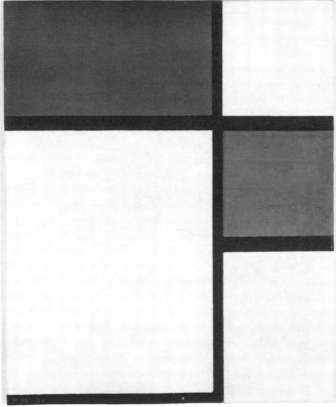

Piet Mondrian
Dutch, 1872–1944
Composition II. 1929
Oil on canvas
15⅞ x 12⅝″

Collection, The Museum of Modern Art, New York. Gift of Philip Johnson

approached the idea of abstraction in art in a completely different way. After his academic training in the Netherlands, he went to Paris and moved through Impressionism, Pointillism and Cubism. Like Kandinsky he was a theosophist and was also interested in Oriental philosophy. It wasn't until World War I, when he returned to the Netherlands, that he began to make his "grid" paintings. He helped start the publication *De Stijl*—"The Style"—whose contributors proposed that the straight line was the only art form that could be used truly creatively. The Impressionists had seen no straight lines in nature; Mondrian and his followers eliminated nature from their art by using only straight lines. What Mondrian was striving for, in dividing space with lines and blocks of primary color on his canvas, was a balance, harmony and order that only art can accomplish. Mondrian envisioned these paintings as helping to bring balance and harmony into daily life.

Because the art of architecture is abstract, nonrepresentational and based on straight lines from the foundation blueprints to the wall structures, many adherents of de Stijl moved into designing buildings. In transferring their style to architecture, they stripped all extraneous, representational ornamentation from churches, houses, office buildings in order to show the man-made straight lines. This combination of two separate art forms, painting and architecture, was the first step toward modern building design.

Mondrian spent the last few years of his life in the United States, where he was considered a symbol of de Stijl principles. His work still influences the design of many items of daily life—furniture, housewares, interior decoration, textiles, poster art, for example.

Georgia O'Keeffe is considered the first woman artist to gain recognition in the American modern art scene. In her early work she was influenced by Kandinsky, sensing as he did the similarity between music and abstract painting.

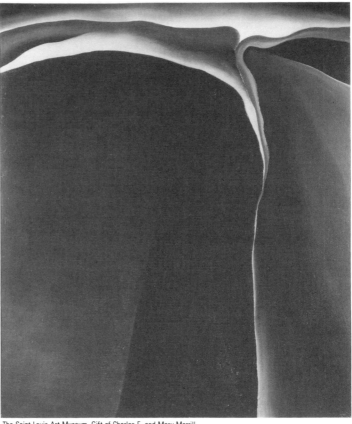

Georgia O'Keeffe
American, 1887–1986
Dark Abstraction. 1924
Oil on canvas
24⅞ x 20⅞"

The Saint Louis Art Museum. Gift of Charles E. and Mary Merrill

Later she moved from abstraction to a more realistic style. She is best known for large, closeup paintings of flowers and for the dramatically stark desert scenes she painted after moving to New Mexico. "The plains—the wonderful big sky—make me want to breathe so deep I'll break," she wrote.

DADAISM: 1916–1922
A Rocking Horse or ?
Duchamp, Arp, Schwitters

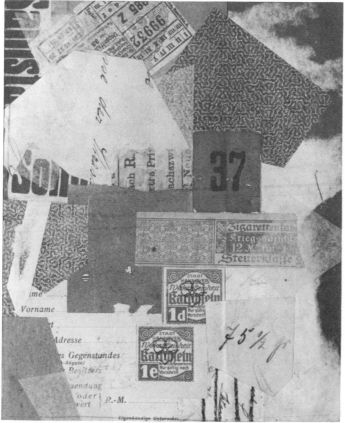

Kurt Schwitters
German, 1887–1948
Merz 19. 1920
Collage, 7¼ x 5⅞"

Yale University Art Gallery, New Haven. Collection, Société Anonyme

The origin of the name Dada is still debated. The originators of the movement were young artists and writers from France, Germany and Rumania living in exile in Zurich during World War I. The story is told that one day they opened a French/German dictionary at random and picked the word *dada,* French for "rocking horse." But for the Rumanians present, *dada* was Slavonic for "yes, yes." As the movement spread, artists in other countries translated the word as "baby talk" or "meaninglessness."

The Dadaists produced very strange "art." Duchamp collected "ready-mades"—discarded objects such as an old urinal that he entitled "Fountain," signed R. Mutt and entered in an art exhibition. The curator, nonplussed, had to leave it in the show but discreetly hid it behind a screen. Another ready-made Duchamp found was a photograph of Leonardo da Vinci's *Mona Lisa.* Duchamp penciled a moustache and goatee on her face and put his name on it. He was the first to use the idea of "appropriation," taking an art object or work and proclaiming it his by virtue of using it (more on this technique later).

Jean Arp made collages "according to chance." Tearing up pieces of colored paper, he dropped them on to a larger sheet of paper, then glued them wherever they fell.

Kurt Schwitters collected scraps and junk from the streets—empty cigarette packets, bits of string, wire—and made a series of collages he called *Merz*—trash, in German.

The public was shocked, as the Dadaists wanted it to be. They were not being silly or childish; they were making a statement against war. At the beginning of World War I, Europe had had peace for forty years. Then, in a surge of patriotism, men went off to fight for the glory of their various homelands. It was the first world war ever. It was to be the war to end all wars and was supposed to last only a few months. Two years later, in 1916, the end wasn't in sight. Dadaism erupted as a protest. Horrified by the terrible

destruction that reduced men and all their hopes and dreams to rubbish, the disillusioned artists, poets, musicians, and writers questioned the meaning of it all. If the leaders of the world thought war was a rational solution to humanity's problems, then why not try irrational solutions

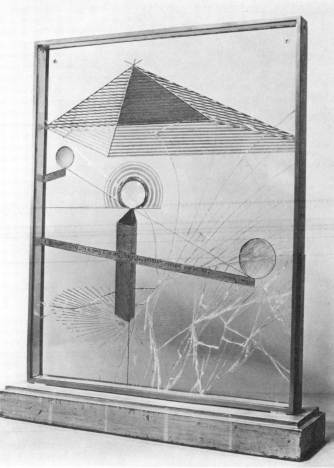

Marcel Duchamp
American, 1887–1968
To Be Looked At (From the Other Side of the Glass) with One Eye, Close To, for Almost an Hour. 1918
Oil paint, silver leaf, lead wire, and magnifying lens on glass (cracked), 19½ x 15⅝", mounted between two panes of glass in a standing frame

Collection, The Museum of Modern Art, New York

Jean (Hans) Arp
French, 1887–1966
*Collage Arranged According to
the Laws of Chance.* 1916–17
Torn and pasted paper
19⅛ x 13⅝″

Collection, The Museum of Modern Art, New York

instead? What was the use of creating new art? Just use the junk around you. The war treated as junk much of what people had valued anyway. In effect, Dada was a move to end all art. The Dadaists held impromptu parties, happenings and exhibitions at which they wore crazy costumes and recited gibberish. A poet cut words out of newspapers, shook them up in a bag, then scattered them around and composed a poem as he picked up the pieces.

Dadaism did not bring about the end of art. Life is short, but art goes on. Ironically enough, some of Dada's "anti-art" is considered fine art today, especially the creations of Arp and Schwitters. (Duchamp's most celebrated work, *Nude Descending a Staircase* shown on page 6, was done during his Cubist period preceding Dadaism.)

One thing Dadaism did was make a break from the rigidness, the stiffness, of the Cubists' geometric shapes. Marcel Duchamp, a former Cubist and a leader in the Dada movement, said (of Dadaism), that it was a "sort of nihilism . . . a way to get out of a state of mind . . . to get away from clichés—to get free." From whimsical anti-art pranks, he progressed to glass paintings, which he considered ridiculous comments about art and the world in general. In the illustration here, look at the title! Did Duchamp ever expect a viewer to take him seriously and follow those instructions? The picture is a strange mixture of accurate linear perspective and completely unrelated objects.

Dadaism was short lived. Duchamp abandoned painting altogether in his midthirties but continued to exert an enormous influence on artists and collectors. Arp and other Dadaists moved into Surrealism, and Arp eventually became a noted sculptor. Schwitters had written, "Everything had broken down and new things had to be made out of fragments." He continued using trash for collages, but his eye for design and color prevented the results from being arrangements "by chance."

SURREALISM: 1924–1930s
Cats, Dogs and Hamburgers talk
Ernst, Dali, Magritte, Miró

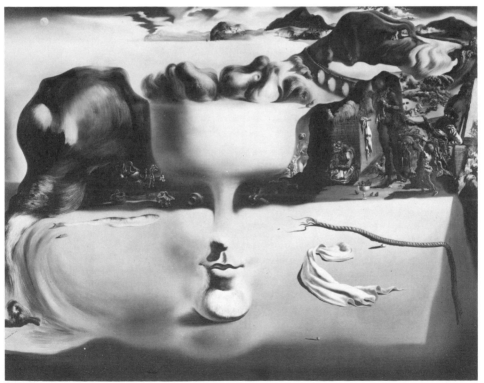

Salvador Dali
Spanish, 1904–1989
*Apparition of Face and Fruit-
 dish on a Beach*. 1938
Oil on canvas, 45 x 56⅝"

Wadsworth Atheneum, Hartford. The Ella Gallup Sumner and Mary Catlin Sumner Collection.
Photo: Joseph Szaszfai

Why is it that when cats, dogs, hamburgers and raisins "talk" in TV commercials, viewers aren't outraged? We find such distortions of reality either amusing or silly, but we accept them. We've grown accustomed to seeing the real and the fantastic or magical blended together in ways that blur the differences between them. A magazine ad for perfume shows a beautiful woman wearing a bent Eiffel Tower for a hat; children wear slippers made to look like bears' feet or like pink rabbits. We sleep under sheets imprinted with zebra stripes, ocean waves, floral arrangements.

The source of such quirky, dreamlike combinations of fact and fantasy can be traced to Surrealism which succeeded Dadaism. The Dadaists had used "chance" and ready-mades in incongruous, illogical ways as a statement against the irrationality of World War I. Postwar artists were further disillusioned. Peacetime brought more miseries—unemployment, poverty, soup lines, the Great Depression and the threat of Nazism. Artists, unwilling to continue the

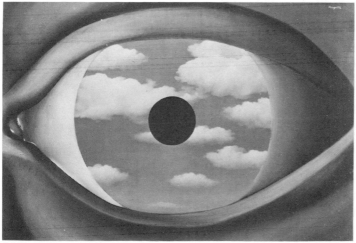

René Magritte
Belgian, 1898–1967
The False Mirror. 1928
Oil on canvas, 21¼ x 31⅞"

Collection, The Museum of Modern Art, New York

meaninglessness of Dadaism, looked for something other than these realities in daily life and found it in the super-real—Surrealism—the world of dreams.

They didn't start painting dreams off the top of their heads. They were influenced by Freud and the then-new theories of two mental worlds. When awake and conscious, we accommodate to the real world of daily life. But asleep and unconscious, we retreat to the private, super-real world of dreams, where anything can happen. Long-"forgotten" faces and places from the real world, and fantasies, desires and fears buried or suppressed in the unconscious world since childhood—or since just last week—emerge and fuse in an illogical way.

To the artists then, the real, the visible world began to look like the tip of an iceberg. Challenged by the vast hidden areas of the unconscious and the possibilities of using

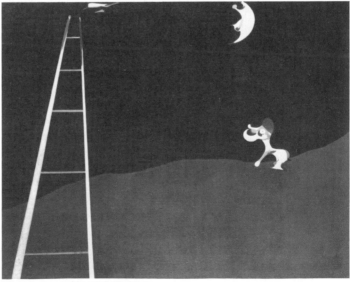

Joan Miró
Spanish, 1893–1983
Dog Barking at the Moon. 1926
Oil on canvas, 28⅞ x 36⅓"

Philadelphia Museum of Art. A.E. Gallatin Collection

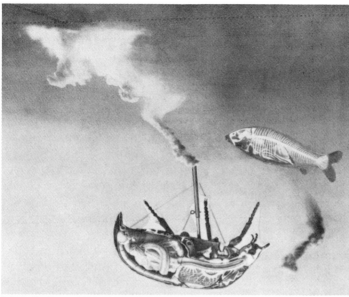

Collection, The Museum of Modern Art, New York

unlimited imagination, they began painting dreams—both
fanciful ones and nightmares.

The variety of results on canvas evoked a wide range of
reactions from viewers at the time and still does today. Some
paintings are seen as bizarre; others as haunting, disturbing,
sinister, repulsive or humorous. The sex and violence in
some would be rated X by Hollywood standards today. On
the other hand, moviemakers were early influenced by Sur-
realism. The classic *King Kong* was a favorite of Surrealist
artists in the thirties. Decades later, in the movie *Star Wars*,
we see incongruous, illogical but delightful combinations of
humans and imaginative nonhumans seated at a "real" bar
in a surrealistic setting on another planet. Surrealism has
infiltrated our daily real life and has, in many ways, freed our
own imaginations.

The paintings shown here might strike you as odd because they use linear perspective and realism. Did the Surrealists reject modern art innovations? After all, the modern art movements preceding it had supposedly freed artists from such traditional stuff. Being "free," however, meant that the artist could use any style he wished. The Surrealists combined the real world with the super-real world of dreams.

Max Ernst, who had no formal art training, had been a prominent Dadaist, then became a founder of Surrealism. In both movements, he used collage on painted backgrounds and often found a double identity in objects. The steamboat in the picture here is an anatomical drawing of a beetle upside-down; the X-ray of a fish overhead could be an airship.

Dali, Magritte and Miró had attended traditional art schools. Salvador Dali is considered the embodiment of Surrealism, largely because of his flamboyant, eccentric lifestyle. In the painting here, Dali has also used double identities—a characteristic borrowed from dreams. The "face" in the title is part of the stem of the fruit bowl (you may need a magnifying glass); the mountain behind it is the body of a dog whose head appears on the center right-hand side.

René Magritte, like Dali, maintained the realistic, traditional painting technique with linear perspective, perhaps to emphasize the strange subject matter. Joan Miró, on the other hand, sometimes combined abstract forms with traditionally painted scenes, or he painted whimsical fantasies, humorous shapes, on top of a flatly painted background.

ABSTRACT EXPRESSIONISM: 1945–1950s
With Gestural Sweeps, Objects Disappear
Pollock, De Kooning, Frankenthaler, Noland

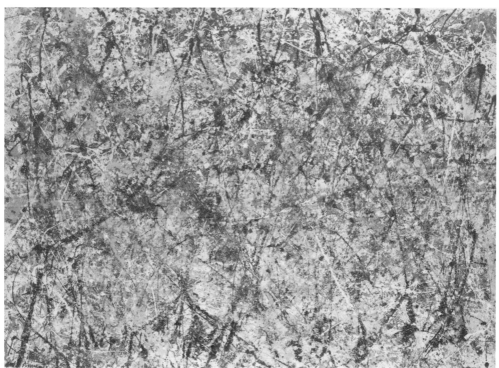

National Gallery of Art, Washington, D.C. Ailsa Mellon Bruce Fund

Jackson Pollock
American, 1912–1956
Number 1, 1950 (Lavender Mist).
Oil, enamel and aluminum on
canvas, 87 x 118"

"Jack the Dripper," as Jackson Pollock has been called, did more than drip paint on huge canvases tacked to his studio floor. He also poured, splattered and tossed it directly from cans. With a stick, he applied spots and blobs of paint on the canvas, pulling weblike lines from them. To a viewer looking for hidden messages in his work, Pollock advised, "It's just like a bed of flowers. You don't have to tear your hair out over what it means."

Pollock had been a realistic painter in the thirties. In the forties, influenced by Cubism, Surrealism and Kandinsky's abstractions, he began painting big, upright canvasses with thick paint using brushes and palette knife. One critic described this "new style" as partly Abstract, partly Surrealistic, and suggestive of Expressionism.

In 1947, Pollock did his first large drip painting. Conjectures vary as to how he arrived at putting the canvas on the floor and giving up brushes. Maybe he accidentally knocked over a can of paint and watched the paint spread itself out. Or maybe he stepped on a tube of paint and as the ribbon of color shot out, liked the expressive energy of the medium, which usually is manipulated by the artist's brush.

A Pollock drip painting might at first glance seem like doodling on a huge scale, but look again. You can get lost in the webs and nets and layers of color. Art historians point out that Pollock borrowed (not to be confused with copied) from most of the earlier modern movements. Under the influence of Kandinsky, he removed recognizable objects from his painting. As in Surrealism, the unconscious world intrudes upon the "real" world. As for the Dadaists, paint, like Arp's pieces of paper, lands on the canvas "by chance." Pollock's emotional application of color harks back to the early expressiveness of Van Gogh.

Pollock has become indelibly linked with Abstract Expressionism, the first modern art movement to originate in America. The idea underlying Abstract Expressionism

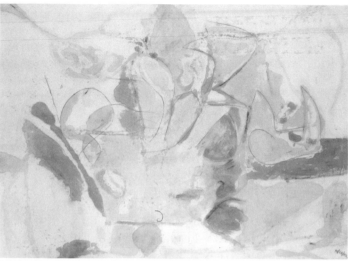

Helen Frankenthaler
American, 1928–
Mountains and Sea. 1952
Oil on canvas, 86 x 117"

Collection of the artist, on loan to the National Gallery of Art, Washington, D.C.

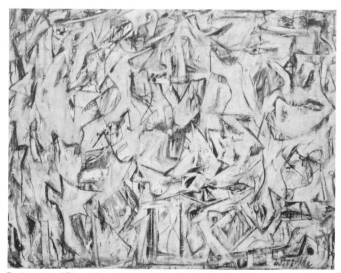

Willem De Kooning
American, 1904–
Excavation. 1950
Oil and enamel on canvas,
 80 x 100"

The Art Institute of Chicago. Mr. and Mrs. Frank G. Logan, Purchase Prize, Gift of Mr. and Mrs. Noah Goldowsky and Edgar Kaufmann, Jr., 1952. © The Art Institute of Chicago. All rights reserved.

was to break away from recent movements such as Cubism, with its rigid geometric shapes, and the abstract geometric art seen, for example, in Mondrian's carefully planned grids. Abstract Expressionism challenged artists to express themselves with spontaneity, to assert themselves as individuals. Several highly diverse styles flourished simultaneously in the movement. The work of Pollock, De Kooning and others was called Action painting. With little or no preconceived plan, they applied paint in sweeping motions. Visible brushstrokes became significant aspects of the composition. In his drip paintings, Pollock rarely used brushes, but his application of paint was nonetheless gestural. In "Excavation," Willem de Kooning broke up his canvas in a Cubist way, but he applied the paint thickly in free, gestural brushstrokes never seen in Cubism.

In the early fifties, Pollock and others sensed that Action painting had served its purpose (as had happened in other modern art movements). Pollock, the chief innovator, was killed in a car crash in 1956.

Artists moved away from Action painting in various ways without giving up the individual freedom of expression of Abstract Expressionism. In Color Field painting, they applied color to large areas of canvas without visible brushstrokes. Helen Frankenthaler is a major pioneer in Color Field painting, using the "soak and stain" technique. She was working in Cubist style but changed after seeing Pollock's drip paintings. She puts a large canvas on the floor and, instead of first painting it with the traditional undercoating to make the canvas nonabsorbent, pours diluted oil colors directly onto the raw canvas. As the canvas soaks up the paint, an effect of staining or dyeing is produced; colors blend with others or fade into the white canvas. The result is similar to watercolor painting but on a huge scale.

Another concept coming out of Abstract Expressionism is Hard Edge art, in which the artist is concerned with

the relationship of sharply defined shapes to the space on the canvas. The severe bars of color in the picture by Kenneth Noland shown here divide space in a completely different way from that of the melting edges of Color Field paintings.

To the untrained eye, the process of making stripes seems simple. A viewer with a young daughter remarked, "Why, I could do that!" Her daughter said, "But mother, you didn't." So much depends on the width of the bands and the interaction of the colors. Stripes of red, black and pink placed side by side evoke a particular visual sensation; if the black is replaced with orange, the sensation is entirely different. The position of the stripes on the canvas space is equally important. Note the title of Noland's picture. Turn it upside down for a very different visual reaction.

Kenneth Noland
American, 1924–
Bend Sinister. 1964
Synthetic polymer on canvas,
92½ x 162½"

Hirshhorn Museum and Sculpture Garden, Smithsonian Institution. Gift of Joseph H. Hirshhorn, 1966

POP ART: 1955–1960s
Campbell's Soup Cans, Comics and Our Flag
Rauschenberg, Johns, Warhol, Lichtenstein

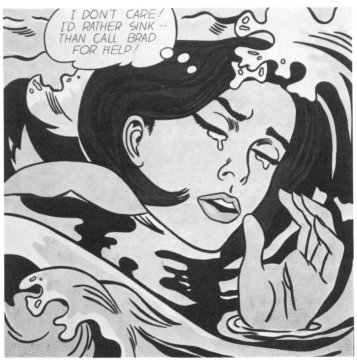

Roy Lichtenstein
American, 1923–
Drowning Girl. 1963
Oil and synthetic polymer
paint on canvas
67⅝ x 66¾"

Collection, The Museum of Modern Art, New York. Philip Johnson Fund and gift of Mr. and Mrs. Bagley Wright. Photo: Rudolph Burckhardt

In the 1850s Courbet, leader of the Realism movement, had advised artists to paint only what they could see. He was rebelling against the traditional subjects in paintings of the previous centuries: Greek and Roman gods, religious and allegorical figures that no artist on earth had ever seen. One hundred years later, Pop artists returned to Courbet's advice. However, their reasons for returning to Realism and the reality they painted would have astonished Courbet.

Pop artists were rebelling against Abstract Expressionism, which frequently had no subject matter at all. Not even imaginary angels could be found in Action, Hard Edge or Color Field paintings. But Courbet's original idea of Realism was to show ordinary people in scenes of daily life. Warhol and Lichtenstein, leaders of Pop, depicted not ordinary people but the objects that surround people daily— rows of cans in supermarkets, comic strip characters, portraits of movie stars —in short, popular culture.

The shock of Pop art was that it had the nerve to mix fine art and commercial art. "Fine art" is a personal reflection on canvas of a particular artist who is expressing what he sees in the outside world or in his inner world. What the artist transmits in his one-of-a-kind creation is uniquely perceived by each individual viewer, whose reaction—he may relate to the subject matter or be inspired, awed or disgusted—is a personal experience.

On the other hand, commercial art doesn't require or expect an individual reaction. It might consider the viewer to be mindless. Commercial artwork illustrates ads in newspapers, billboards, magazines. The purpose of ads is to appeal to the consumer in us, not the esthete. Most commercial art is thrown away eventually; fine art hangs in homes or museums indefinitely or forever.

The Pop artist painted subjects from throw-away commercial art in the media of advertising and entertainment. Its defiance of Abstract Expressionism was shocking to art

critics and serious art viewers. After all, Abstract Expressionism was the first truly American contribution to the modern art movement. Now seemingly, Pop artists were ridiculing it by reintroducing not only recognizable objects but ones heretofore considered vulgar or commonplace. In the past, Van Gogh, Kandinsky and other artists had been concerned that materialism was smothering the universal spirit of mankind. Pop artists, with the same concern, chose to convey their message by presenting blatant fragments of popular, materialistic culture as their art.

Rauschenberg and Johns, in the 1950s, were the first to rebel against Abstract Expressionism by reintroducing recognizable objects, thus establishing the foundation for Pop art. Robert Rauschenberg questioned the Abstract Expressionists' assumption that art is the product of the artist's mind, which is capable of straining out influences from the outside world. In 1955 he created his "combine" paintings—combinations of collage and paint. Influenced by the Dadaists—Schwitters and Duchamp—he picked up

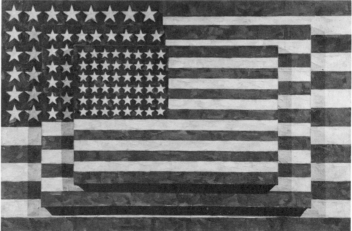

Jasper Johns
American, 1930–
Three Flags. 1958
Encaustic on canvas
30⅞ x 45½ x 5″

Collection, Whitney Museum of American Art, New York. 50th anniversary gift of the Gilman Foundation, Inc., The Lauder Foundation, A. Alfred Taubman, an anonymous donor, and purchase. Photo: Geoffrey Clements

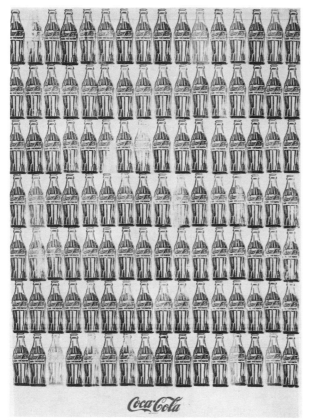

Andy Warhol
American, 1928?–1987
Green Coca-Cola Bottles. 1962
Oil on canvas, 82½ x 57″

Collection, Whitney Museum of American Art, New York. Purchase with funds from the Friends of the Whitney Museum. Photo: Geoffrey Clements

trash on the littered streets of New York City and made large environmental collages. But his use of ready-mades was not a return to the anti-art of Dadaism. Instead, he wanted to bring the world and art together, to work "in the gap between art and life." He said, "There is no reason not to consider the world as one gigantic painting." One of his well-known combine paintings consists of a mattress, pillow and

Robert Rauschenberg
American, 1925–
Factum I. 1957
Combine painting
61½ x 35¾"

Collection, The Museum of Contemporary Art, Los Angeles. The Panza Collection. Photo: Squidds and Nunns

quilt nailed to a wall and painted over with the gestural brushstrokes of the Action painters. "Factum I," shown here, is a combination of unrelated items—printed matter and painted objects, dripped paint and paste-ons. He followed it up with "Factum II," an almost identical picture to prove in a tongue-in-cheek manner that "spontaneous" art (as in Abstract Expressionism) could be duplicated.

Jasper Johns concentrated on a familiar object, such as the U.S. flag, and painted with thick encaustic—pigment mixed with wax, a technique of the Old Masters (an odd reversion to the past). Many viewers were shocked. Was he insulting Old Glory? Perhaps the shock was eye-level confrontation with a flat, complete view of this patriotic symbol which usually hangs high over our heads, limply or waving in the wind. Johns painted many flag pictures—mostly of a single flag. He also painted targets, a bull's eye and rows of numbers that appear to have been stenciled on the canvas.

Warhol and Lichtenstein are the painters most closely associated with Pop art. Andy Warhol, who had been a financially successful commercial artist, is best known for his multiple images—most notable, his *200 Campbell's Soup Cans*—reflecting the advertising media's insistent, persistent, repetitious method. Using the same technique, he did portraits of entertainment idols like Marilyn Monroe and Elvis Presley, and prominent public figures such as Jackie Kennedy, seeing them as part of the popular culture of the times.

Roy Lichtenstein had been an Abstract Expressionist and also a commercial artist. Moving into Pop art, he took for subject matter the heroes, heroines and villains from comics of the thirties and forties. He even copied the benday dots used in reproducing pictures in newspapers and comic books. The picture here is close to the size seen in comics; the original painting is actually huge—about six and one-half feet square.

OP ART: 1960s
Strictly for the Retina?
Riley and others

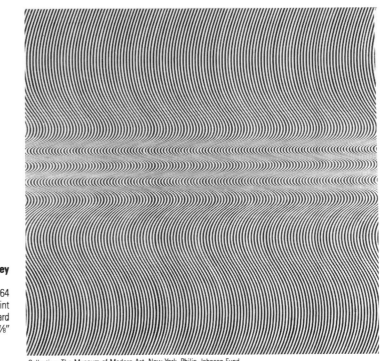

Bridget Riley
British, 1931–
Current. 1964
Synthetic polymer paint
on composition board
58¾ x 58⅞"

Collection, The Museum of Modern Art, New York. Philip Johnson Fund

If you have a headache, don't look at Op art; it could increase your distress. An Op (for optical) art painting creates an optical illusion—nothing new in the history of art. Mathematical perspective in traditional paintings has "fooled" the eye for centuries by giving the impression of depth on a flat canvas. Then early in the nineteenth-century modern art movement, Seurat invented Pointillism, another example of illusion. His figures look solid but in reality are made up of millions of separate dots. Cubists, Surrealists and other modern artists use other illusions in different ways.

For these artists, however, illusion is only one component. Pictures also include subject matter or abstract forms, color, composition; the eye relays the whole picture to the viewer's senses. But in Op art, illusion is the main component of the picture. It confronts the eye directly; the first look causes a physical rather than an emotional reaction. Try holding the picture here about twenty inches in front of you; the lines seem to undulate, sometimes receding, sometimes coming forward. They seem to be moving, but you know they can't be.

Pop and Op art occurred at the same time in the mid-sixties. They were used commercially in magazine and newspaper ads, in high-style and teenage clothing. Fabric designs included cans, comics and imitation Op art. Bridget Riley, recognized as an important Op artist, wrote that "my work has been vulgarized" and that the "explosion of commercialism, bandwagoning and hysterical sensationalism" had hidden the real qualities of what she was doing. The craze didn't last long.

In the late sixties Riley moved from black-and-white to color Op art. Color seems to add an emotional reaction to the physical one of Op art. Look in museums for Riley's color paintings and those of Victor Vasarely and Richard Anuskiewicz.

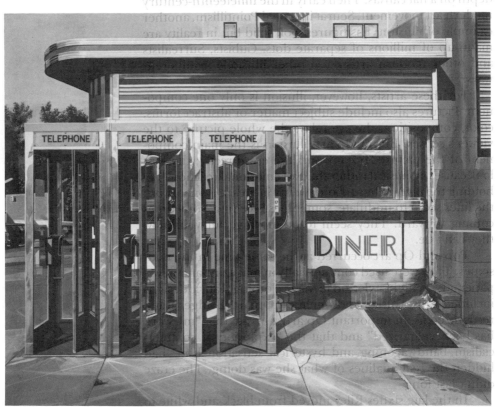

EPILOGUE: 1970–1990s
Here Today and Maybe Tomorrow

Richard Estes
American, 1936–
Diner. 1971
Oil on canvas
40⅛ x 50"

Hirshhorn Museum and Sculpture Garden, Smithsonian Institution, Washington. Purchase, 1977

Much art of the seventies and eighties is called Postmodern. The implication seems to be that after one hundred years, the modern art movement, begun as a protest against traditional painting, has achieved its purpose. By the fifties, with the advent of Abstract Expressionism, all traditional rules for painting had finally been broken. In the sixties, Pop artists smashed the glass wall between fine and commercial art. One might think that no shocks were left. Viewers, including pregnant women, could relax and enjoy paintings without distress.

Indeed, nerve ends were given a rest in the seventies. There was a return to Realism; human figures, objects, outdoor scenes were again recognizable. Separate small groups appeared—Postpop, Post-this and Post-that. A solid contribution was Photo Realism. The artist would record, with a camera, a selective view, usually a city scene. He would then project a slide of the photograph onto a huge canvas and paint it in the most minute detail. At the time, critics scoffed: "A visual soap opera," "rat-trap compositional formulas," "a triumph of mediocrity." Later, Photo Realism was recognized as an art form, a combination of modern technology and art, much more than just a tinted photograph. But Photo Realism couldn't be called a new movement; it was another form of Realism. In general, looking back on the seventies, historians of modern art have declared that no outstanding movement developed during the decade.

Art of the eighties is still referred to as Postmodern—an umbrellalike term waiting for a significant new art statement to replace it. The art scene is becoming noisier and noisier as we move into the nineties. Groups of young artists have introduced additional "styles"—Neopop, Neo-expressionism, Neo-geometrics and more—but their work continues to be categorized as Postmodern. Then there is Appropriation, where an artist enlarges a photograph of a reproduction—or paints a copy from a reproduction—of a work by

an artist such as Pollock, Malevich, Mondrian, Miró—and signs his or her own name to it, thus "appropriating" it. This harks back to Duchamp and ready-mades, which were part of the Dadaists' anti-art movement.

The cry, "Is this ART?," has accompanied each modern art movement in the past. It seems even louder and more frequent in this Postmodern era. Despite such skepticism, the work of a number of young artists finds a market with collectors eager to invest in a future Van Gogh or Pollock. They pay outrageous prices, gambling on the prospect of future millions, for work that may prove to be a passing fad. Critics decry this approach to collecting, seeing it as a form of commercialization.

No one can predict how long a fad will last. In some cases, a young artist may be merely sowing wild oats before finding his real direction. Art critics at the end of the eighties have already singled out some who are maturing.

In the fifties and sixties, the work of Johns, Rauschenberg, Lichtenstein, Warhol and others was considered faddish. Today, these artists are acclaimed internationally. (Since his death in 1987, Warhol's work has been in even greater demand by private collectors and museums.)

Johns moved on from his flags and targets to painting, on one canvas, separate objects such as a woman's head, vases and a skull, in a collage-like style. In 1988, he represented the United States in the Venice Bienniale, a prestigious international art show. An international jury judged him the best living artist in the show. That year a 1962 painting of his was sold for seven million dollars, the highest price ever paid for work by a living artist. Topping this record within the same week, another Johns painting was sold for seventeen million dollars.

Rauschenberg, who once said, "There is no reason not to consider the world as one gigantic painting," has been traveling around the globe doing environmental works.

Working in his "combine" style, he incorporates objects suggesting a particular country in the work done there. In Japan, for example, he used paper parasols. A huge environmental painting reflecting his multinational interest and entitled *One-fourth Mile or 2 Furlong Piece* was installed in the Lila Acheson Wallace Wing of the Metropolitan Museum in New York in 1987.

Lichtenstein forsook the comics years ago but still uses the same flat drawing style. A great admirer of past modern masters, he combines "moments" from famous paintings by Matisse, Picasso and others in a complex, witty way. In one painting, for example, Matisse's dancing figures are seen outside a window. Lichtenstein's paintings sell for hundreds of thousands of dollars, and in 1987 the Museum of Modern Art in New York staged a retrospective exhibition of his drawings. He is the first living artist to be so honored.

What paintings will hang in museums in the twenty-first century to represent art of the last decades of the twentieth? One thing is certain: a large number of paintings being made today will have disappeared by the turn of the century. They will have physically destroyed themselves—a phenomenon unique in art history—because they have been made, often intentionally, with impermanent materials.

Artists have been experimenting with materials other than paint since Braque and Picasso introduced collage; they have now gone far beyond pieces of newsprint and scraps of cloth pasted on relatively small paintings. Often on huge canvases, artists have now incorporated such objects as dirt, sand, neon lights, glass, chinaware shards, straw, charcoal, leaves, stuffed birds, umbrellas, animal horns, animal fur, chair legs, legs from store display dummies and more. Naturally some of these items deteriorate in time or fall off the picture. When a museum or private collector who may have paid hundreds of thousands of dollars for such a painting reports a mishap to the living artist, reactions vary.

Rauschenberg helps restore his work but says, "Art has risk built into it." An owner of a Johns painting found a fly stuck on it. He left it, not sure whether it was intentional. Later, Johns told him that flies are attracted to encaustic (his medium) and that the fly was not intended to be part of the picture. Other artists don't seem to care what happens to a painting once it's been sold. "My leaves dropping off? Replace them with some of your own. After all, leaves are leaves," one owner was told. Use of impermanent material may be the artist's way of reflecting the instability of life today, some critics point out. Nuclear warheads could wipe out civilization tomorrow—why produce lasting art?

Nevertheless, the purpose of museums is to preserve art for future generations. The possibility of nuclear war isn't factored into their budgets. Curators are becoming cautious. They often reject work made with unstable material, or insist that the artist guarantee restoration should it be needed. Both individual and corporate collectors are thinking twice before buying, and insurance companies are tightening up on what they'll cover.

Impermanence also plagues the work of artists who are no longer living. The collages of Braque and Picasso were not shellacked for preservation; today some of the components are deteriorating, slipping and fading. The paintings of the Abstract Expressionists pose other problems. During the Depression years, artists used cheap materials such as house paints, which are not meant to last forever. As a result, in works of Pollock and others, paint is peeling and colors changing. Also, because of Pollock's abandoned way of working, bits and pieces of things are stuck in the paint. Recently a conservator found a cigarette butt in a thick web of paint. He left it there. In Color Field paintings, raw, unpainted portions of canvas are becoming discolored and dirtied from air pollution; they are difficult to clean.

Art conservators, trained to restore oil paintings that

are hundreds of years old, are now faced with paintings that need restoring after only ten or fifteen years. What they can do in view of the use of impermanent materials is limited. Some of these paintings aren't going to last much longer.

Despite this rather gloomy prospect, art itself will endure. In the mid-1800s, it was feared that photographs would replace painted pictures. It created, instead, a reappraisal of art and a new approach to it. The modern art movement was born. Today photography has progressed far beyond the tintype—witness moving pictures and video-tapes—but visual art has not been replaced. A comparable "threat" today might be the computer; some artists, with the aid of technology and mathematics, are producing astonishing works on computers—including collage, called compulage. What would Picasso and Braque think?

At the same time, Postmodern artists—good or bad—have revitalized public interest. Millions of people are visiting museums, and more and more museums are being built, some of them specifically for modern and Postmodern art.

"All profoundly original art looks ugly at first," an art critic in the fifties said in relation to Abstract Expressionism. Remember that in art more has happened in the last one-hundred years than in all the previous five hundred, and the search for new directions continues. With this in mind, the next time something in a museum or gallery strikes you as ugly or foolish, don't just walk by. Look again!

FURTHER READING

Alloway, Lawrence. *American Pop Art.* New York: MacMillan, 1974.

Arnason, H. H. *History of Modern Art: Painting, Sculpture, Architecture.* New York: Abrams, 1968.

Battcock, Gregory, ed. *The New Art: A Critical Anthology.* New York: E. P. Dutton, 1966.

Batterberry, Michael. *Twentieth Century Art.* New York: McGraw-Hill, 1969.

De la Croix, Horst, & R. G. Tansey, eds. *Gardner's Art Through the Ages.* New York: Harcourt, Brace & World, 1970.

Gombrich, E. H. *The Story of Art.* London: Phaidon, 1972.

Haslam, Malcolm. *The Real World of the Surrealists.* New York: Rizzoli, 1978.

Honour, Hugh, and John Fleming. *The Visual Arts: A History.* Englewood Cliffs, NJ: Prentice Hall, 1982.

Hughes, Robert. *The Shock of the New.* New York: Knopf, 1981.

Janson, H. W., and Anthony F. Janson. *History of Art for Young People.* New York: Abrams, 1987.

Lucie-Smith, Edward. *Art in the Seventies.* Ithaca: Cornell University Press, 1950.

Lynton, Norbert. *The Story of Modern Art.* Ithaca: Cornell University Press, 1980.

Museum of Contemporary Art. *Individuals: A Selected History of Contemporary Art, 1945–1986.* New York: Abbeville Press, 1986.

Myron, Robert, and Abner Sundell. *Modern Art in America.* New York: Crowell-Collier Press, 1971.

Picon, Gaeton. *Modern Painting: From 1800 to the Present.* New York: Newsweek Books, 1974.

Rubin, William, ed. *Pablo Picasso: A Retrospect.* New York: Museum of Modern Art, 1980.

Russell, John. *The Meanings of Modern Art.* New York: Harper & Row, 1981.

Whitford, Frank. *Kandinsky.* London: Paul Hamlyn, Ltd., 1967.

Also look for articles and art show reviews in newspapers, in weekly publications such as *New York* magazine, *Newsweek, The New Yorker,* and in art magazines such as *ARTnews, ARTFORUM, Art and Antiques.*

INDEX